... the Sand

¿Qué anda buscando est...
también? ¿Qué bu...
al agua, ¿Qué busca...
la orilla?
La verdad es que hice mi casa
allí entre las rocas para espe-
rar de la arena, para estar allí
mismo cuando salga. ¿Cuando
salga qué cosa? Hasta ahora
alcanzan a las costas fragmentos,
espinas, cascaritas, anuncias.
Lo grande no lo trae el mar
todavía. Los que aquí vivimos
sabemos que es cosa de esperar—
dormidos o despiertos, y que el hallazgo
nos halle confesados. Confesados de
la esperanza que tuvimos en el vaivén,
en la sal, en el movimiento salino del
silencio. Oceánidas, todos a la
orilla. Todos en las líneas del mar.

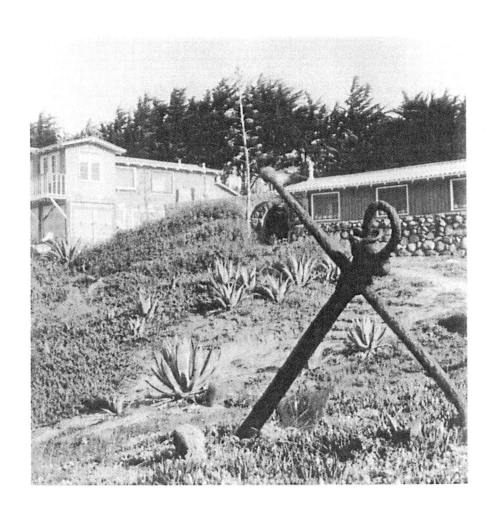

The House in the Sand

Prose Poems by
PABLO NERUDA

Photographs by
MILTON ROGOVIN

Translated by
Dennis Maloney & Clark M. Zlotchew

FOREWORD BY MARJORIE AGOSÍN
AFTERWORD BY ARIEL DORFMAN

WHITE PINE PRESS

THE HOUSE IN THE SAND
Published by White Pine Press
P.O. Box 236, Buffalo, New York 14201

The text in this book was published originally by
Milkweed Editions, Minneapolis, Minnesota.

Printed and bound in the United States of America.

First Edition

ISBN 978-1-893996-74-8

Publication of this book was made possible, in part, with public
funds from the New York State Council on the Arts, a State Agency.

Library of Congress Control Number: 2003116766

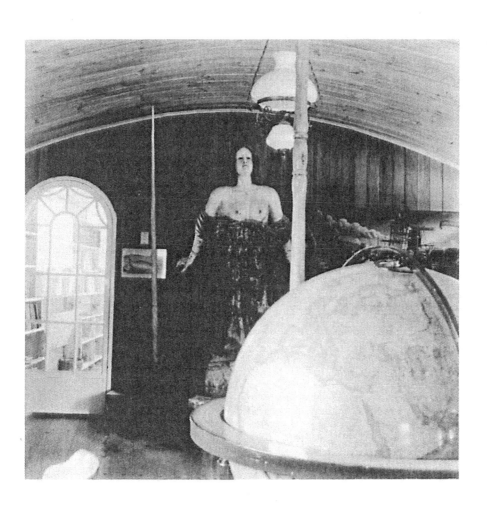

Foreword

I return to Isla Negra in the month of March, when the tourists have left. Most of them return to the nearby city of Santiago, Chile, 120 kilometers from the coast, tan, nostalgic for the summer days and the calm, blue sea that contains "the salt of seven leagues, horizontal salt, crystalline salt of the rectangle, stormy salt, the salt of seven seas, salt."

I return in the month of March, when the sand regains its magical texture. In its voluntary desolation, the shore allows those who know to stay behind to collect the agate stones left on its infinite outline: "agates of Isla Negra, mist colored or light blue, softly carmine or deep green, or violet or reddish or variegated on the inside like clusters of muscat grapes: and often static with transparency, open to the light, surrendered by the honeycomb of the ocean to the whim of the crystal: to purify itself."

A deep silence envelops the shore, but it is a superficial silence. Once one begins to explore its dirt roads, its spaces of shadow and light, the island fills with birds. An almost golden breeze and the odor of fresh bread, of burning flour, float along the sweet air of the coast. An energy penetrates the skin of visitors, who learn to love Isla Negra, which, according to Neruda, isn't black nor an island, but rather a fishermen's cove.

I grew up on Isla Negra and little by little, with the passage of time and history, it became a site both mythical and real: a setting for magical, soaring birds and a coastal village besieged by political violence. Nevertheless, the presence of Pablo Neruda continues and still flourishes on the island: "Spring begins with a great yellow labor. Everything is covered with innumerable, miniscule golden flowers. Later the little pale

flowers fade and everything is covered with an intense violet florescence. The heart of spring goes from yellow to blue, and then to red."

Lost in the innocence of a tranquil childhood, we grew up with the poet's maritime and celestial imagery. We were accustomed to seeing him in the morning, contemplating the Pacific Ocean for hours and hours with a fixed gaze, obsessed by the impressive radiance of the waves. After he walked on the great expanses of rock that surrounded the island, we would see him, dressed in an enormous Araucanian poncho, climb up to a cottage that seemed to be suspended between the earth and the sky. In that seaside cabana, far from the house farther inland, Neruda would write for hours, filling enormous notebooks with green ink. His poetry germinated and took root here, returning to the continual rebirth of the sea.

Between lunchtime and siesta, Isla Negra surrendered to a delicious peace. Even the chickens, seagulls, fish, and cats reclined, enjoying the sun's caresses, and the poet slept his great marine siesta, his daily requirement, next to the swells and warmth of his beloved Matilde.

Very late in the afternoon, the first lights would appear among the pine trees. Don Pablo, as the local children, who grew up hearing his verses, called him, would leave. The bard would again walk along the coast, jumping over rocks with the disbelief and amazement of a naughty child.

From a young age, I shyly followed Don Pablo's footsteps. I would greet him from afar and follow his wanderings on the deserted beach, where I found pieces of colored glass that seemed to be messages from strange travelers or part of Matilde's agate necklaces. He once gave me a postcard that said, "Come to my house to hear the giant bells." And so I approached the celestial experiences of Pablo Neruda with the humility and timidity of one who knows she is in the presence of an unusual and jovial person.

Once Neruda gave me honeysuckle and some dark

rocks that were the color of the night in Isla Negra. He told me: "You now have part of the universe in your pocket."

I saved the lessons of this enigmatic, generous, and kind figure, as well as the spirit of his words, which I carry with me as a secret talisman. I keep returning to Isla Negra because I never left it, and even if I were blindfolded, I would find it.

The honeysuckle that Neruda picked for me continue to bloom in the garden near his house, and from the garden waft the sweet scents of love as well as the phrases that visitors and lovers carve on the fence. For example, "Pablo will never die," "Free Chile," or simply "Pablo and Matilde loved each other here." This time, I can't gather the honeysuckle, but I collect a few stones, and keep them in my pocket. Because these stones " . . . perhaps they were fragments of a deafening explosion. Or stalagmites that were once submerged, or hostile fragments of the full moon, or quartz that changed destiny, or statues that time and the wind broke into pieces . . . or golden tortoises, or imprisoned stars . . . or granite sparks that stood still."

"Here, said Don Eladio Sobrino (a seafarer), and here we remained. Later the house began to grow, like people, like the trees. Later Don Eladio died. He was very old and was a tireless and cheerful man. Captain Sobrino was Andalusian. The last time he came to see us, he sang ancient mountain songs and sea chanties all afternoon. On the very day on which he stopped singing and sailing forever, I climbed the ladder, and on the great sailing schooner that hangs suspended over the fireplace, I wrote his name in capital letters. So, the ship built for me in Veracruz, Mexico, by emigrant Spanish sailors . . . is called the *Don Eladio*."

I approach the house with my friend, Eduardo Vera, grandson of Eladio Sobrino. Don Eladio was the one who made building this house possible. Eduardo and I recall his grandfather, dead yet always present, as well as our young friends, disappeared, gone, transformed by the course of a

painful and perverse history. Then I remember the flag: "But in midwinter the flag thrashes up there with its fish in the air trembling with cold, with wind, and with sky."

We enter the house, and there are the immense bells, noble in the purity of their sound, slipping in through the air's crevices, speaking, describing the presence of the poet who navigated these rooms. The house is occupied by faded figureheads whose names were repeated in conversation on Isla Negra as if they were beloved sweethearts. We all knew of the loves of Maria Celeste and of Micaela, the last to arrive in the house, corpulent, self-confident, with colossal arms. We go further into the house, so inhabited by the presence of its owners that it is as if they have just gone out for a stroll in search of a bit of fresh air.

Everything remains in its place in the house in the sand, including the anchor that stands in dignified silence like a ship. We go outside and the sun is more and more overwhelming, making us feel life beating in our skin, which begins to meld with the ocean. There is the gardener, whose name we do not know, because he has been hired by the Neruda Foundation. He nonetheless greets us with a tip of the hat and shows us the flowers that continue to grow, including the one that "no one outside of my country would know. . . . It exists nowhere but on these antarctic shores. It is called chahual (*puya chilensis*). This ancestral plant was worshiped by the Araucanians. Ancient Arauco no longer exists. Blood, death, time, and then Ercilla's epic harp put an end to the ancient story: the tribe of clay that suddenly woke from geology and went to defend its native land against the invaders. When I see its flowers spring forth once more, above centuries of obscure deaths, above layers and layers of bloody oblivion, I believe that the past of the land blossoms against what we are, against what we are now. The land alone remains, defending its essence."

Now I return to the shore, tattooed by the absences of

loved ones, by the intertwined spirits of Pablo and Matilde, because they protect the shore from bad winds and fill it with songbirds. I return to Eduardo Vera's house, which faces Pablo and Matilde's house. As children, we watched them from this house, watching their hands as transparent as light as they tended the *docas*. How we loved the *docas*: "I don't know if these plants, creeping along the sand on their triangle fingers, multiplied by millions, exist in other places. The spring filled these drooping hands with unaccustomed rings the color of amaranth. These *docas* have a Greek name, *aizoaceae*. The splendor of Isla Negra on these days of late spring are the *aizoaceae* which pour out a marine invasion like an emanation from a sea grotto of the racemes that the Sailor accumulated in his Neptune's vault."

We remember the violent destruction of Neruda's other house, the house of La Chascona at the foot of San Cristobal hill in Santiago, which was leveled by the perversity of cowards. And we remember how they entered the house in the sand, but they were unable to damage or destroy the figureheads. They were also unable to erase the names that were inscribed "on the roofbeams [not] because they were famous, but because they were companions . . . Rojas Gimenez . . . Joaquin Cifuentes . . . Federico . . . Paul Eluard . . . Miguel Hernandez . . . Why did they leave so soon? . . . Each one of them was a victory. Together they were the sum of my light. Now, a small anthology of my sorrows."

I think that perhaps the people whose names adorn Don Pablo's beams are present: among others, Rafita, the carpenter, and the incredible Doña Elena, who reigned over the Isla Negra Inn, where Neruda used to lunch on her enormous and delicious cold eels.

The first lights are illuminated on Isla Negra, the wind bleats like a bird, and the rocks still contain the warmth of the first morning rays. Eduardo and I head toward the inn to have a glass of warm red wine, as Don Pablo preferred it. The *docas*

below on the beach illuminate our path. Lovers continue with their nightly ceremonies of kisses and memories. As they light a candle for Don Pablo, next to the wooden fence, we greet them and smile with nostalgia. I think of Don Eladio Sobrino, and I head toward the sea, I collect some stones and, this time, honeysuckle. I am happy, and next year I will return to the house in the sand. "The house . . . I don't know when it was born in me . . . It was in the midafternoon, we were on the way to those lonely places on horseback . . . Don Eladio was in front, fording the Cordoba stream. . . . Later the house began to grow, like people, like the trees" because neither time or death will diminish its splendor or its winged roof.

—Marjorie Agosin
translated by Janice Molloy,
except for quotations
from the text

The House in the Sand

Foreword by Marjorie Agosin

PROSE POEMS BY PABLO NERUDA

The Key / 16

The Sea / 18

The Sea / 20

The Sea / 22

The Sea / 24

The Sand / 26

The Agates / 28

The Plants / 30

Nobel Prize on Isla Negra (1963) / 32

The Stones / 40

The House / 42

Don Eladio / 44

The People / 46

The People / 48

The Names / 50

Whale Tooth / 52

The Medusa / 66

The Medusa II / 70

The Shipwright / 74

Ceremony / 76

Big Chief of the Comanches / 78
The Mermaid / 80
The Marie Celeste / 82
The Bride / 84
Cymbelina / 86
Beauty / 90
Micaela / 92
The Flag / 94
The Anchor / 96
The Locomotive / 98
Love for this Book / 100
The Sea / 104
The Sea / 106
The Sea / 108
The Sea / 110
The Sea / 112
The Sea / 114
The Sea / 116

Afterword by Ariel Dorfman / 119

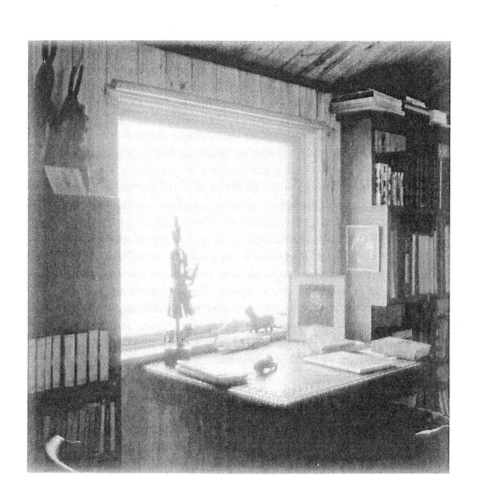

La Llave

Pierdo la llave, el sombrero, la cabeza! La llave es la del almacén de Raúl, en Temuco. Estaba afuera, inmensa, perdida, indicando a los indios el almacén "La Llave". Cuando me vine al Norte se la pedí a Raúl, se la arranqué, se la robé entre borrasca y ventolera. Me la llevé a caballo hacia Loncoche. Desde allí la llave, como una novia blanca, me acompañó en el tren nocturno.

Me he dado cuenta de que cuanto extravío en la casa se lo ha llevado el mar. El mar se cuela de noche por agujeros de cerraduras, por debajo y por encima de puertas y ventanas.

Como de noche, en la oscuridad, el mar es amarillo, yo sospeché sin comprobar su secreta invasión. Encontraba en el paragüero, o en las dulces orejas de María Celeste gotas de mar metálico, átomos de su máscara de oro. Porque el mar es seco de noche. Guardó su dimensión, su poderío, su oleaje, pero se transformó en una gran copa de aire sonoro, en un volumen inasible que se despojó de sus aguas. Por eso entra en mi casa, a saber qué tengo y cuánto tengo. Entra de noche, antes del alba: todo queda en la casa quieto y salobre, los platos, los cuchillos, las cosas restregadas por su salvaje contacto no perdieron nada, pero se asustaron cuando el mar entró con todos sus ojos de gato amarillo.

Así perdí la llave, el sombrero, la cabeza.

Se los llevó el océano en su vaivén. Una nueva mañana las encuentro. Porque me las devuelve una ola mensajera que deposita cosas perdidas a mi puerta.

Así, por arte de mar la mañana me ha devuelto la llave blanca de mi casa, mi sombrero enarenado, mi cabeza de náufrago.

The Key

I lost my key, my hat, my head! The key came from Raul's general store in Temuco. It was outside, immense, lost, pointing out the general store, "The Key," to the Indians. When I came north I asked Raul for it, I tore it from him, I stole it in the midst of fierce and stormy winds. I carried it off toward Loncoche on horseback. From there the key, like a bride dressed in white, accompanied me on the night train.

I have come to realize that everything I misplace in the house is carried off by the sea. The sea seeps in at night through keyholes, underneath and over the tops of doors and windows.

Since by night, in the darkness, the sea is yellow, I suspected, without verifying, its secret invasion. On the umbrella stand or on the gentle ears of Maria Celeste, I would discover drops of metallic sea, atoms of its golden mask. The sea is dry at night. It retains its dimension, its power, and its swells, but turns into a great goblet of sonorous air, into an ungraspable volume that has rid itself of its waters. It enters my house to find out what and how much I have. It enters by night, before dawn: everything in the house is still and salty, the plates, the knives, the things scrubbed by contact with its wildness lose nothing, but become frightened when the sea enters with all its cat-yellow eyes.

That is how I lost my key, my hat, my head.

They were carried off by the ocean in its swaying motion. I found them on a new morning. They are returned to me by the harbinger wave that deposits lost things at my door.

In this way, by a trick of the sea, the morning has returned to me my white key, my sand-covered hat, my head— the head of a shipwrecked sailor.

El Mar

El Océano Pacífico se salía del mapa. No había donde ponerlo. Era tan grande, desordenado y azul que no cabía en ninguna parte. Por eso lo dejaron frente a mi ventana.

Los humanistas se preocuparon de los pequeños hombres que devoró en sus años:

No cuentan.

Ni aquel galeón cargado de cinamomo y pimienta que lo perfumó en el naufragio.

No.

Ni la embarcación de los descubridores que rodó con sus hambrientos, frágil como una cuna desmantelada en el abismo.

No.

El hombre en el océano se disuelve como un ramo de sal, Y el agua no lo sabe.

The Sea

The Pacific Ocean was overflowing the borders of the map. There was no place to put it. It was so large, wild and blue that it didn't fit anywhere. That's why it was left in front of my window.

The humanists worried about the little men it devoured over the years.

They do not count.

Not even that galleon, laden with cinnamon and pepper that perfumed it as it went down.

No.

Not even the explorers' ship—fragile as a cradle dashed to pieces in the abyss—which keeled over with its starving men.

No.

In the ocean, a man dissolves like a bar of salt. And the water doesn't know it.

El Mar

El Mar del Sur! Adelante, descubridores! Balboas y La Perouses, Magallanes y Cookes, por aquí, caballeros, no tropezar en este arrecife, no enredarse en el sargazo, no jugar con la espuma! Hacia abajo! Hacia la plenitud del silencio! Conquistadores, por aquí! Y ahora basta!

Hay que morir!

The Sea

The South Sea! Forward, discoverers! Balboas and La Perouses, Magellans and Cook's, over here gentlemen, don't stumble on this reef, don't get tangled in the sargasso, don't play with the foam! Head for the bottom! Toward the fullness of silence! Conquistadors, over here! That's enough now!

One has to die!

El Mar

 *Y siguen moviéndose la ola, el canto y el cuento,
y la muerte!*
 *El viejo océano descubrió a carcajadas a sus
descubridores. Sostuvo sobre su movimiento maoríes
inconstantes, fijianos que se devoraban, samoas comedores de
nenúfares, locos de Rapa Nui que construían estatuas, inocentes
de Tahiti astutos de las islas, y luego vizcaínos, portugueses,
extremeños con espadas, castellanos con cruces, ingleses con
talegas, andaluces con guitarra, holandeses errantes. Y qué?*

The Sea

And the wave, the song, and the tale continue to move. And so does death!

With peals of laughter, the old ocean discovered its discoverers. It sustained on its moving surface inconstant Maoris, Fijians who devoured each other, water-lily-eating Samoans, madmen from Rapa Nui who constructed statues, innocents from Tahiti, the cunning men of the islands, and later Basques, Portuguese, Extremadurans with swords, Castilians with crosses, Englishmen with moneybags, Andalusians with guitars, flying Dutchmen. And so what?

El Mar

 El mar los descubrió sin mirarlos siquiera, con su contacto frío los derribó y los anotó al pasar en su libro de agua.
 Siguió el océano con su sacudimiento y su sal, con el abismo. Nunca se llenó de muertos. Procreó en la gran abundancia del silencio. Allá la semilla no se entierra ni la cáscara se corrompe; el agua es esperma y ovario, revolución cristalina.

The Sea

The sea discovered them without even looking at them; with its cold contact it knocked them down and listed them, in passing, in its book of water.

The ocean remained with its heaving and salt, with the abyss. It never became filled with the dead. It procreated, in the great abundance of silence. There the seed is not buried nor does the rind of fruit rot; the water is sperm and ovary, a crystalline churning.

La Arena

Estas arenas de granito amarillo son privativas,
insuperables, (La arena blanca, la arena negra se adhieren a la
piel, al vestido, son impalpables e intrusas.) Las arenas doradas
de Isla Negra están hechas como pequeñísimos peñascos como si
procedieran de un planeta demolido, que ardió lejos, allá
arriba, remoto y amarillo.

Todo el mundo cruza la ribera arenosa y agachándose
y buscando, removiendo, tanto que alguien llamó a esta costa
"la Isla de las cosas Perdidas".

El Océano es incesante proveedor de tablones
carcomidos, bolas de vidrio verde o flotadores de corcho,
fragmentos de botella emnoblecidos por el oleaje, detritus de
cangrejos, caracolas, lapas, objetos devorados, envejecidos por la
presión y la insistencia. Existe entre espinas quebradizas o erizos
minúsculos o patas de jaiva morada, el serpentino cochayuyo,
nutrición de los pobres, alga interminable y redondo como una
anguila, que resbala y brilla, sacudida aún en la arena por la ola
reticente, por el océano que la persigue. Y ya se sabe que esta
planta del mar es la más larga del planeta creciendo hasta
cuatrocientos metros, prendida con un titánico chupón al
roquerío, sustentándose con una división de flotadores que
sostienen la cabellera del alga macrocristis con millares de tetitas
de ámbar. Y como en el territorio andino vuela el cóndor y
sobre el mar chileno se reúnen planeando todas las familias del
albatros y como el cachalote o ballena dentada se sumergió en
nuestras aguas y aquí sobrevive, somos una pequeña patria de
alas muy grandes, de cabelleras muy largas sacudidas por el gran
océano, de presencias sombrías en las bodegas del mar.

The Sand

These sands of yellow granite are unique, insurmountable. (The white sand, the black sand, adhere to the skin, to the clothing, they are impalpable and intrusive.) The golden sands of Isla Negra are formed like tiny spheres of rock, as if they originated in some demolished planet, which burned far away, up there remote and yellow.

Everyone walks across the sandy shore and crouches, searching, picking through the sand, to such an extent that someone called this coast "the Island of Lost Things."

The ocean is an incessant provider of half-rotted planks, balls of green glass or cork floats, fragments of bottles ennobled by rough seas, detritus of crab shells, conch shells, limpets, objects that have been eaten away, aged by pressure and insistence. It lives among brittle fish skeletons, miniscule sea urchins or purple crabs, serpentine *cochayuyo*, nourishment of the poor—interminable seaweed, round as an eel that slides and shines, made to quiver even on the sand by the reticent wave, by the ocean which pursues it. It's well known that this sea plant is the longest on the planet, growing to a length of four hundred meters, attached to the rocks by titanic suction, maintaining itself with a division of floaters which sustain the tresses of the macrocrystis algae with thousands of little amber nipples. And since the condor flies over the Andean region and all the families of the albatross glide in for their reunions on the Chilean waters and survive here, we are a small homeland of very large wings, of very long tresses tossed by the great ocean, of shadowy presences in the great vaults of the sea.

Las Agatas

Pero de dónde vienen a mis mano sestas ágatas! Cada mañana aparecen frente a mi puerta, y es la arrebatiña auroral, pues algún extraviado pastor de tierra adentro, o González Vera, o Lina o María pueden disputar las pequeñas piedras translúcidas a los Yankas, mariscadores de oficio, que, al pie del mar, acechan la mercadería, y se creen con derecho a cuanto bota la ola.

Lo cierto es que ellos me madrugaron siempre y he aquí una vez más el tesoro que me manda el mar, solo en sus manos, a tanto la piedra o las cien piedras o el kilo o el tonel.

Y en la mano las misteriosas gotas de luz redonda, color de la miel o de ostra, parecidas a uvas que se petrificaron para caber en los versos del Genil de Espinosa, suavemente espolvoreadas por alguna deidad cenicienta, horadadas a veces en su centro por algún aguijón de oro, socavadas como por la más diminuta de las olas: ágatas de Isla Negra, neblinosas o celestes, suavemente carmíneas o verdiverdes, o avioletadas o rojizas o ensaladas por dentro como racimos moscateles: y a menudo estáticas de transparencia, abiertas a la luz, entregadas por el panal del océano al albedrío del cristal: a la pura pureza.

The Agates

 Where do these agates come from into my hands?
Each morning they appear at my doorstep, and it is an early-
morning scramble, since some stray shepherd from inland,
either González Vera, or Lina or Maria fights over these small
translucent stones with the Yankas, shellfish gatherers by trade,
who, at the edge of the sea, lie in wait for merchandise and
think they are entitled to whatever the tide casts ashore.

 The truth is that they always wake me at dawn, and
here again is the treasure the sea sends me, alone in its hands,
at so much per stone or per hundred stones or per kilo or per
barrel.

 And in my hand the mysterious drops of round light,
the color of honey or of oyster, resembling petrified grapes in
order to fit into Espinosa's poem about the Genil River, softly
sprinkled by some ashen deity, at times bored through the
center by some golden spur, undermined by the tiniest of
waves: agates of Isla Negra, mist-colored or light blue, softly
carmine or deep green, or violet or reddish or variegated on the
inside like clusters of muscat grapes: and often static with
transparency, open to the light surrendered by the honeycomb
of the ocean to the whim of the crystal: to purity itself.

Las Plantas

 Nadie conoce apenas, o todos desconocen en vilo, estas plantas hirsutas de la orilla. Pregunté muchas veces, a éste y al otro, pero tuve evasivas respuestas de pescadores, campesinos o chiquillos. En verdad nadie sabe cómo se llama el pellejo de uno, la piel de la oreja: no tiene nombre el cutis que te rodea el ombligo: y estas vegetaciones castigadas por el viento salobre son la piel y el pellejo del territorio marino.

The Plants

Hardly anyone knows, or rather, everyone is completely unaware of these bristly plants along the seashore. I have asked over and over but have received only evasive responses from fishermen, peasants and children. Indeed, no one knows the name of one's own skin, the skin of the ear—the skin that surrounds your navel has no name—and these forms of vegetation, punished by the salty wind are the skin and the hide of this seaside territory.

Premio Nobel
En Isla Negra

(1963)

Cuando por la radio dijeron, repitiéndolo varias veces, que mi nombre se discutía entre los otros candidatos al Premio Nobel de Literatura, Matilde y yo pusimos en práctica el plan no 3 de Defensa Doméstica. Pusimos un candado grande en el viejo portón de Isla Negra y nos pertrechamos de alimentos y vino tinto. Agregué algunas novelas policiales a estas perspectivas de enclaustramiento.

Los periodistas llegaron pronto. Los mantuvimos a raya. No pudieron traspasar aquel portón. El gran candado de bronce no sólo es bello, sino poderoso. Detrás de él rondaban como tigres. Qué se proponían Qué podía decir yo de una discusión en que sólo tomaban parte académicos suecos en el otro extremo del mundo? Sin embargo, ahí estaban los periodistas mostrándome con sus miradas sus intenciones de sacar agua de un palo seco. Pronto emigraron.

La costa quedaba libre de amenaza. No obstante, continuamos invisibles.

La primavera ha sido tardía en este año de 1963, en el litoral del Pacífico Sur. Estos días solitarios me sirvieron para intimar con la primavera marina. Aunque tarde se había engalanado para su solitaria fiesta. Durante el verano no cae una sola gota de lluvia. La tierra es gredosa, hirsuta, pedregosa. No se ve una brizna verde. En el invierno el viento del mar desata furia, sal, espuma de las grandes olas, y la naturaleza aparece acongojada, víctima de una fuerza terrible.

La primavera comienza con un gran trabajo amarillo. Todo se cubre con innumerables, minúsculas flores doradas.

Nobel Prize
On Isla Negra
(1963)

When they said on the radio, repeating it several times, that my name was being discussed among the other candidates for the Nobel Prize for Literature, Matilde and I put into operation Plan No. 3 for Domestic Defense. We put a large padlock on the big old gate to Isla Negra, and we stocked up on food stuffs and red wine. I added some detective novels to these prospects of being shut in.

The journalists soon arrived. We kept them at a distance. They couldn't get beyond the gate. The great bronze padlock is not only beautiful, but powerful. Behind it they paced up and down like tigers. What were they planning to do? What could I say about a discussion in which only Swedish professors at the other end of the world were taking part? Nonetheless, there the newspapermen were, showing me by their glances that they intended to squeeze water out of a stone. They soon left.

The coast was clear. Nonetheless, we remained invisible.

Spring came late in 1963 to the South Pacific coast. These days of solitude allowed me to become very familiar with spring at the seashore. However, it adorned itself late for its solitary party. During summer, not one single drop of rain falls. The earth is clayey, bristly, rocky. Not one blade of green is visible. In winter the sea wind unleashes fury, salt, foam from the huge waves, and nature appears anguished, the victim of a terrible force.

Spring begins with a great yellow labor. Everything is

Estas germinaciones pequeñas y poderosas cubren laderas, rodean las rocas, se adelantan hacia el mar y aparecen en medio del camino, allá donde hay que pisar todos los días, como si quisieran desafiarnos, probarnos su existencia. Tanto tiempo sostuvieron una vida invisible, la desolada negación de la tierra estéril, que ahora todo les parece poco para su fecundidad amarilla.

Luego se van las pequeñas flores pálidas y todo se cubre con una intensa floración violeta. El corazón de la primavera pasó del amarillo al azul, y luego al rojo. Cómo se sustituyeron unas a otras las pequeñas, desconocidas, infinitas corolas? Lo cierto es que un día el viento sacudía un color y luego otro color, como si allí, entre aquellas colinas, cambiara el pabellón de la primavera, y sus repúblicas diferentes ostentaran los estandartes de la invasión.

En esta época florecen los cactus de la costa. Lejos de esta región, en los contrafuertes de la cordillera andina, los cactus se elevan gigantescos, estriados y espinosos, como columnas hostiles. Los cactus de la costa son pequeños y redondos. Ahora los vi coronarse cada uno con veinte botones escarlata, como si una mano hubiera dejado allí su tributo de sangre. Pero se abrieron y frente a las grandes espumas se divisan miles de cactus encendidos por sus flores plenarias.

El viejo agave de mi casa sacó desde el fondo de su entraña su floración suicida. Esta planta, azul y amarilla, gigantesca y carnosa, duró más de diez años junto a mi puerta, creciendo hasta ser más alta que yo. Y ahora florece para morir. Erigió una poderosa lanza verde que subió hasta siete metros de altura, interrumpida por una seca inflorescencia, apenas cubierta por polvillo de oro. Luego, las hojas colosales del agave americana *se desploman y mueren.*

*Junto a la gran flor que muere, he aquí otra flor titánica que nace. Nadie la conocerá fuera de mi patria. No existe sino en estas orillas antárticas. Se llama chahual (*puya chilensis*). Esta planta ancestral fue adorada por los araucanos.*

34

covered with innumerable, miniscule golden flowers. These tiny but strong germinations cover slopes, surround rocks, advance toward the sea, and appear in the middle of the road, there where one has to walk every day, as though they wanted to defy us, to prove to us that they exist. They maintained an invisible life for so long, the desolate negation of the sterile earth, that now no effort is too great for their yellow fertility.

Later the little pale flowers fade and everything is covered with an intense violet florescence. The heart of spring goes from yellow to blue, and then to red. How do these tiny, unknown, infinite corollas replace each other? What's certain is that one day the wind shook one color and suddenly another one appeared, as if out there, among those hills, it was changing the banner of spring, and its different republics were displaying the pennants of invasion.

During this season the coast cacti flourish. Far from this region, in the spurs of the Andean range, the cacti rise up gigantic, striated, and thorny, like hostile columns. The coast cacti are small and round. Now I saw each one of them being crowned with twenty scarlet buds, as though a hand had left its tribute of blood there. But they opened, and facing the great foam one spies thousands of cacti inflamed by the fullness of their flowers.

The old agave by my house brought forth from the depths of its insides its suicidal florescence. This plant, blue and yellow, gigantic and fleshy, survived for more than ten years beside my door, growing until it was taller than I. And now it is blossoming so it may die. It sent up a powerful green spike that climbed to seven meters in height, interrupted by a dry inflorescence hardly covered by gold dust. Later, the colossal leaves of the *agave americana* collapse and die.

Right beside this large flower that is dying, is another titanic flower being born. No one outside of my country would know it. It exists nowhere but on these antarctic shores. It is called chahual (*puya chilensis*). This ancestral plant was

35

Ya el antiguo Arauco no existe. La sangre, la muerte, el tiempo y luego el arpa épica de Ercilla cerraron la antigua historia: la tribu de arcilla que despertó bruscamente de la geología y salió a defender la tierra patria contra los invasores. Al ver surgir sus flores otra vez, sobre siglos de oscuros muertos, sobre capas y capas de sangriento olvido, creo que el pasado de la tierra florece contra lo que somos, contra lo que somos ahora. Sólo la tierra continúa siendo, defendiendo la esencia.

Pero olvidé describirla.

Es una bromeliácea de hojas agudas y aserradas. Irrumpe en los caminos como un incendio verde, acumulando en una panoplia sus misteriosas espadas. Pero, de pronto, una sola colosal flor, un racimo le nace de la cintura, como una inmensa rosa verde de la altura de un hombre. Esta única flor compuesta, como un pólipo marino, de una muchedumbre de florecillas que se agrupan en una sola catedral verde, coronada por el polen de oro, resplandece a la luz del mar. Es la única inmensa flor verde, el verde monumento de la ola.

Los campesinos y los pescadores de mi país olvidaron hace tiempo los nombres de las pequeñas plantas, de las pequeñas flores que no tienen nombre. Poco a poco lo fueron olvidando y lentamente las flores perdieron su orgullo. Se quedaron enredadas y oscuras, como las piedras que los ríos arrastran desde la nieve andina hasta los desconocidos litorales. Campesinos y pescadores, mineros y contrabandistas, estuvieron dedicados a su propia aspereza, a la continua muerte y resurrección de sus deberes y derrotas. Es difícil ser héroes de territorios aún no descubiertos: la verdad es que en ellos, en su pobreza, no resplandece sino la sangre anónima y florecen las flores cuyo nombre nadie conoce.

Entre ellas hay una que ha invadido toda mi casa. Es una flor azul de largo y orgulloso talle. Este talle es lustroso y resistente. En su extremo se balancean las múltiples florecillas infra-azules. No sé si a todos les será dado contemplar el más excelso azul. Será revelado sólo a algunos y permanecerá

worshipped by the Araucanians. Ancient Arauco no longer exists. Blood, death, time and then Ercilla's epic harp put an end to the ancient story: the tribe of clay that suddenly woke from geology and went to defend its native land against the invaders. When I see its flowers spring forth once more, above centuries of obscure deaths, above layers and layers of bloody oblivion, I believe that the past of the land blossoms against what we are, against what we are now. The land alone remains, defending its essence.

But I forgot to describe it.

It is bromeliaceous with sharp serrated leaves. It springs up on the roads like a green fire, accumulating its mysterious swords in a panoply. But suddenly, one single colossal flower, a raceme, is born at its waist, like an immense green rose the height of a man. This single flower composed, like marine polyp, of a bunch of little flowers grouped into a single green cathedral, crowned with golden pollen, glowing with the light of the sea. It is the only immense green flower, the green monument to the waves.

The peasants and the fishermen of my country forgot the names of the small plants with the tiny flowers a long time ago. They forgot them little by little, and the flowers slowly lost their pride. They were left tangled and obscure, like stones the rivers drag from the Andean snow to unknown seacoasts. Peasants and fishermen, miners and smugglers, were devoted to their own roughness, to the continual death and resurrection of their duties and defeats. It is difficult to be heroes in territories that still have not been discovered: the truth is that in them, in their poverty, nothing stands out but anonymous blood and flowers whose name no one knows.

Among them there is one which has invaded my entire house. It is a blue flower with a long, proud stem. This stem is lustrous and strong. At its tip sway the multiple, tiny, infra-blue flowers. I don't know if everyone has had the privilege of gazing on this most sublime blue. I wonder if it is revealed only

cerrado, invisible, para algunos otros humanos a quienes algún dios azul les negará esta contemplación? O se tratará de mi propia alegría, nutrida en la soledad y transformada en orgullo al encontrarme este azul, esta espiga azul, este fuego azul, en la abandonada primavera?

Por último hablaré de las docas. No sé si existen en otras partes estas plantas, millonariamente multiplicadas, que arrastran por la arena sus dedos triangulares. La primavera Llenó estas manos caídas con insólitas sortijas de color amaranto. Estas docas llevan un nombre griego: aizoaceae. *El esplendor de Isla Negra en estos tardíos días de primavera son las* aizoaceae *que derraman una invasión marina, como la emanación de la gruta del mar, de los racimos que acumuló en su bodega Neptuno Marinero.*

Y, justo en este momento, la radio nos anuncia que un buen poeta griego ha obtenido el renombrado Premio. Ya, Matilde y yo, nos quedamos tranquilos. Con solemnidad retiramos el gran candado del viejo portón para que todo el mundo siga entrando sin llamar a las puertas de mi casa, sin anunciarse. Como la primavera.

to some, and remains closed, invisible, for other humans to whom some blue god denies this sight. Or is it only my own joy, nourished in solitude and transformed into pride when I come upon this blue, this blue spike, this blue fire, in the abandoned spring?

Finally I shall speak of the *docas*.

I don't know if these plants, creeping along the sand on their triangular fingers, multiplied by millions, exist in other places. The spring filled these drooping hands with unaccustomed rings the color of amaranth. These docas have a Greek name, *aizoaceae*. The splendor of Isla Negra on these days of late spring are the *aizoaceae* which pour out a marine invasion like the emanation from a sea grotto of the racemes that Neptune the Sailor accumulated in his vault.

And just at this moment, the radio announces to us that a good Greek poet has been awarded the renowned Prize. Finally that's over. Matilde and I are calm. With solemnity we remove the large padlock from the old gate so everyone may continue to enter, without knocking at the doors of my house, without announcing themselves. Like the spring.

Las Piedras

Piedras, peñas, peñascos . . . Tal vez fueron
segmentos del estallido. O estalagmitas alguna vez sumergidas o
fragmentos hostiles de la luna llena o cuarzo que cambió de
destino o estatuas que el tiempo y el viento trizaron y sobaron o
mascarones de navíos inmóviles o muertos gigantes que se
transmutaron o tortugas de oro o estrellas encarceladas o
marejadas espesas como lava que de pronto se quedaron quietas
o sueños de la tierra anterior o verrugas de otro planeta o
centellas de granito que se detuvieron o pan para antepasados
furiosos o huesos oxidados de otra tierra o enemigos del mar en
sus bastiones o simplemente piedra rugosa, centellante, gris,
pura y pesada para que construyas con fierro y madera una casa
en la arena.

The Stones

Stones, boulders, crags . . . Perhaps they were
fragments of a deafening explosion. Or stalagmites that were
once submerged, or hostile fragments of the full moon, or
quartz that changed destiny, or statues that time and the wind
broke into pieces or kneaded into shapes, or figureheads of
motionless ships, or dead giants that were transmuted, or
golden tortoises, or imprisoned stars, or ground swells as thick
as lava which suddenly became still, or dreams of the previous
earth, or the warts of another planet, or granite sparks that
stood still, or bread for furious ancestors, or the bleached bones
of another land, or enemies of the sea in their bastions, or
simply stone that is rugged, sparkling, grey, pure and heavy so
that you may construct, with iron and wood, a house in the
sand.

La Casa

La casa . . . No sé cuándo me nació . . . Era a media tarde, llegamos a caballo por aquellas soledades . . . Don Eladio iba delante, vadeando el estero de Córdoba que se había crecido . . . Por primera vez sentí como una punzada este olor a invierno marino, mezcla de boldo y arena salada, algas y cardos.

The House

The house . . . I don't know when this was born in me . . . It was in the mid afternoon, we were on the way to those lonely places on horseback . . . Don Eladio was in front, fording the Cordoba stream which had swollen . . . For the first time I felt the pang of this smell of winter at the sea, a mixture of sweet herbs and salty sand, seaweed and thistle.

Don Eladio

Aquí, dijo don Eladio Sobrino (navegante) y allí nos quedamos. Luego la casa fue creciendo, como la gente, como los árboles. Don Eladio se nos murió, más tarde. Tenía muchos años y era infatigable y alegre. Era andaluz el capitán Sobrino. La última vez que vino a vernos cantó toda la tarde antiguas canciones serranas y marinas. El mismo día que dejó de cantar y navegar para siempre, me encaramé en la escalera, y en la gran goleta velera colgada sobre la chimenea escribí su nombre con letras mayúsculas. Así se llama Don Eladio *la embarcación que hicieron para mí en Veracruz los marineros emigrados del* Manuel Arnús.

(Estaba el gran barco pegado a la ribera, ondulando con todas sus camisetas, sábanas y calzoncillos largos.

Me reconoció la marinería. Me invitaron a sus pobrezas. Y porque cantamos y bebimos juntos, los anduluces construyeron con paciencia este modelo. "De los que salen de Puerto de Santa María," me advirtieron.)

Sobre la chimenea de piedra de Isla Negra navega la Don Eladio. *Qué bien nombrada estuvo!*

Don Eladio

Here, said Don Eladio Sobrino (a seafarer), and here we remained. Later the house began to grow, like people, like the trees. Later Don Eladio died. He was very old and was a tireless and cheerful man. Captain Sobrino was Andalusian. The last time he came to see us, he sang ancient mountain songs and sea chanties all afternoon. On the very day in which he stopped singing and sailing forever, I climbed the ladder, and on the great sailing schooner that hangs suspended over the fireplace, I wrote his name in capital letters. So, the ship built for me in Veracruz, Mexico, by the emigrant Spanish sailors of the *Manuel Arnus* is called *Don Eladio*.

(The great ship was hugging the shore, swaying from side to side with all its undershirts, bedsheets, and long underwear.

The sailors recognized me. They invited me to share in their meager fare. And because we sang and drank together, the Andalusians patiently constructed this model. "Like the ones that sail from Puerto Santa Maria," they informed me.)

The *Don Eladio* sails on the stone fireplace of Isla Negra. How well named it is!

El Pueblo

Cuando años más tarde intervino Germán, el arquitecto, tuvo que entenderse con el maestro mayor don Alejandro. Hay que ver esas manos. No hay piedra que las resista. ni clavo, ni tornillo, ni grapa, ni serrucho, ni martillo, ni perno, ni botella. No hay cantero como él, ni carpintero como él, ni albañil, ni estupendo bebedor de vino tinto como el Maestro Mayor. Aquí por estas orillas, mar infinito (que él no mira), trabajo y vino.

Germán constató cómo don Alejandro levantaba una de esas piedras pesadas y cuadradas, la miraba al trasluz y rápido le volaba una arista. La piedra centelleaba. Y luego se emparedaba en la asociación del cemento. La casa fue así como un racimo de uvas de granito, que se fue granando en las manos tremendas del maestro García.

Germán y yo lo buscábamos arriba entre las vigas, para modificarlo y para mejor aprender.

No había ninguno.

Voló con sus aprendices. No podía ser, sólo era jueves. Pero tal vez el viento de Oceanía que llega de tarde en tarde por la costa, se encontró con los albañiles y con el día jueves, allá encima, en los tijerales. Entonces bajaron o ascendieron al vino más cercano, el de Florencio, y por tres días quedaron los martillos y los combos botados en la arena. Pero, cuidado! Allá arriba, otra vez, trabajando como tremendos, cautelosos titanes. Allí están.

Y don Alejandro García sopesando el adoquín, cortando las uvas del granito, y haciendo crecer mi casa como si ella fuera un arbolito de piedra, plantado y elevado por sus grandes manos oscuras.

The People

When years later Germán, the architect, took a hand in it, he had to come to an understanding with the master builder, Don Alejandro. His hands are something to see. There is no stone that can withstand them. No nail, or screw, or staple, or saw, hammer, bolt, or bottle. There is no stone cutter or carpenter like him, no mason or stupendous drinker of red wine like the Master Builder. Here along these shores, is the infinite sea (which he does not look at), work, and wine.

Germán showed how Don Alejandro would lift one of those heavy, squared stones, look at it against the light, and rapidly trim the edge. The stone would sparkle. And then it would be confined by the application of mortar. In this way the house was like a cluster of granite grapes, which gradually grew in the tremendous hands of the master builder, García.

Germán and I looked for him up among the beams, to learn from him and urge moderation.

No one was there.

He took off with his apprentices. It couldn't be, it was only Thursday. But perhaps the wind from Oceania, that blows along the coast from afternoon to afternoon, came upon the masons and upon Thursday, up there, on the sawhorses. Then they went down or went up to the wine nearest at hand, Florencio's, and for three days the hammers and the discarded stands remained on the sand. But, careful! Up there, again, working like tremendous, cautious titans. There they are.

And Don Alejandro García hefting the paving block, cutting the granite grapes, and making my house grow as if it were a little tree of stone, planted and raised by his great, dark hands.

El Pueblo

 Así como yo me pensé siempre poeta carpintero, pienso que Rafita es poeta de la carpintería. Trae sus herramientas envueltas en un periódico, bajo el brazo, desenrolla lo que me parecía un capítulo y toma los mangos gastados de martillos y escofinas, perdiéndose luego en la madera. Sus obras son perfectas. El chiquillo y el perro lo acompañan y miran sus manos circulando prolijas. El tiene esos ojos de San Juan de la Cruz y esas manos que levantan troncos colosales con tanta fragilidad como sabiduría.

 Escribí con tiza los nombres de mis amigos muertos, sobre las vigas de rauli y él fue cortando mi caligrafía en la madera con tanta velocidad como si hubiera ido volando detrás de mí y escribiera otra vez los nombres con la punta de un ala.

The People

Just as I've always thought of myself as a carpenter-poet, I think of Rafita as the poet of carpentry. He brings his tools wrapped in a newspaper, under his arm, and unwraps what looks to me like a chapter and grasps the worn handles of his hammers and rasps, losing himself in the wood. His work is perfect.

A little boy and a dog accompany him and watch his hands as they move in careful circles. His eyes are like those of Saint John of the Cross, and his hands which raise colossal tree trunks with delicacy as well as skill.

On the rauli wood beams, I wrote with chalk the names of my friends who have died, and he went along carving my calligraphy into the wood as swiftly as if he had flown behind me and written the names again with the tip of a wing.

Los Nombres

No los escribí en la techumbre por grandiosos, sino
por compañeros.

Rojas Giménez, el trashumante, el nocturno,
traspasado por los adioses, muerto de alegría, palomero, loco de
la sombra.

Joaquín Cifuentes, cuyos tercetos rodaban como
piedras del río.

Federico, que me hacía reír como nadie y que nos
enlutó a todos por un siglo.

Paul Eluard, cuyos ojos color de nomeolvides me
parece que siguen celestes y que guardan su fuerza azul bajo
la tierra.

Miguel Hernández, silbándome a manera de ruiseñor
desde los árboles de la calle de la Princesa antes de que los
presidios atraparan a mi ruiseñor.

Nazim, aeda rumoroso, caballero valiente, compañero.

Por qué se fueron tan pronto? Sus nombres no
resbalarán de las vigas. Cada uno de ellos fue una victoria.
Juntos fueron para mí toda la luz. Ahora, una pequeña
antología de mis dolores.

The Names

I didn't write them on the roofbeams because they were famous, but because they were companions.

Rojas Giménez, the nomad, nocturnal, pierced with the grief of farewells, dead with joy, pigeon breeder, madman of the shadows.

Joaquín Cifuentes, whose verses rolled like stones in the river.

Federico, who made me laugh like no one else could and who put us all in mourning for a century.

Paul Eluard, whose forget-me-not color eyes are as sky blue as always and retain their blue strength under the earth.

Miguel Hernández, whistling to me like a nightingale from the trees on Princesa Street until they caged my nightingale.

Nazim, noisy bard, brave gentleman, friend.

Why did they leave so soon? Their names will not slip down from the rafters. Each one of them was a victory. Together they were the sum of my light. Now, a small anthology of my sorrows.

Diente De Cachalote

Del Mar vino algún día
rezumando
existencia,
sangre, sal, sombra verde,
ola que ensangrentó la cacería,
espuma acuchillada
por la erótica forma
de su dueño:
baile
de los
oscuros,
tensos,
monasteriales
cachalotes
en el Sur del océano
de Chile.
Alta
mar
y marea,
latitudes
del más lejano
frío:
el aire
es una
copa
de
claridad helada
por donde
corren
 las alas

Whale Tooth

One day it came from the sea
oozing
existence,
blood, salt, green shadow,
wave which bloodied the hunt,
foam stabbed
by the erotic shape
of its master:
dance
of the
dark,
taut,
monasterial
whales
in the southern ocean
of Chile.
High
seas
and tide,
latitudes
of the farthest
cold:
the air
is a
cup
of
frozen clarity
through which
dash
 the wings

del albatros
como skíes del cielo.

Abajo,
el mar
es una
torre
desmoronada y construida,
una paila en que hierven
grandes olas de plomo,
algas que sobre
el lomo de las aguas
resbalan
como escalofríos.
De pronto sobrevienen
la boca
de la vida
y de la muerte:
la bóveda
del semisumergido
cachalote,
el cráneo
de las profundidades,
la cúpula
que
sobre
la ola eleva
su dentellada,
todo
su
aserradero submarino.
Se encienden, centellean
las ascuas del marfil,
 el agua
inunda

 of the albatross
like skis of the sky.
Below,
the sea
is a
tower
crumbling and reconstructing itself,
a pan in which great
waves of lead boil,
seaweed which slides on
the back of the water
like chills.
Suddenly, there appears
the mouth
of life
and death:
the vault
of the semisubmerged
whale,
the cranium
of the depths,
the dome
which raises
its teeth
over
the waves
all of
its
undersea sawmill.
They light up, sparkle,
those ivory embers,
 the water
inundates
that atrocious smile,
sea and death sail

aquella atroz sonrisa.
mar y muerte navegan
junto
al navío negro que entreabre
como una catedral su dentadura.
Y cuando ya la cola
enfurecida
cayó como palmera
sobre el agua.
el animal
salido del abismo
recibió
la centella
del hombre pequeñito
(el arpón
dirigido
por la mano mojada
del chileno).

Cuando
regresó
de los
mares,
de su sangriento día,
el marinero
en uno
de los dientes
de la bestia
grabó con un cuchillo
dos retratos; una
mujer y un hombre
despidiéndose,
un navegante
por el amor
herido,

beside
the black ship which half opens
that set of teeth like a cathedral.
And when the furious
tail
fell like a palm tree
on the water,
the animal
from the abyss
received
the spark
of the tiny, little man
 (the harpoon
 wielded
 by the drenched hand
 of the Chilean).

When
he returned
from the
seas,
from his blood-soaked day,
the sailor
on one
of the beast's
teeth, carved with a knife
two portraits: a
woman and a man
saying good-bye,
a sailor
wounded
by love,
a sweetheart on the prow
of absence.

una novia en la proa
de la ausencia.

Cuántas
veces tocó mi corazón, mi mano,
aquella
luna
de miel
marina
dibujada
en el diente.
Cómo amé
la corola
del
doloroso
amor
escrita
en marfil
de ballena
carnicera,
de cachalote loco.

Suave
línea
del
beso
fugitivo,
pincel
de flor marina
tatuada
en el hocico
de la ola,
en la fauce terrible
del océano,
en el alfanje

How many
times was my heart, my hand, touched
by that
ocean
honey-moon
sketched
on the tooth.
How I loved
the corolla
of the
sorrowful
love
written
on the ivory
of a carnivorous
whale,
of a mad sperm whale.

Smooth
line
of a
fleeting
kiss,
painter's brush
made of sea flower
tattooed
on the snout
of the wave,
on the terrible jaws
of the ocean,
on the scimitar
unleashed
from
the dark regions:
there

desencadenado
desde
las tinieblas:
allí
estampado
el canto
del amor errante,
la despedida
de los
azahares,
la niebla,
la luz
de aquel
amanccer
mojado
por tempestuosas lgrimas
de aurora ballenera.

Oh amor,
allí
a los labios
del mar,
condicionado
a
un
diente
de la ola,
con el
rumor
de
un
pétalo
genérico
(susurro de ala rota
entre el intenso

is engraved
the song
of errant love,
the farewell
of the
orange blossoms,
the fog,
the light
of that
dawn,
soaked
by the tempestuous tears
of a whaling daybreak.

Oh love,
there
at the lips
of the sea,
subject
to
a
tooth
of the waves,
with the
sound
of
a
generic
petal
(rustle of a broken wing
among the intense
fragrance
of the jasmines,)
(Love
in a hotel that is

olor
de los jazmines),
(amor
de hotel
entrecerrado, oscuro,
con hiedras amarradas
al ocaso),
(y un beso
duro como
piedra que asalta),
luego
entre boca y boca
el mar
eterno,
el archipiélago,
el collar de las
islas
y las naves
cercadas
por el frío,
esperando
el animal azul
de las profundidades
australianas
del océano,
el animal nacido
del diluvio
con su ferretería
de zafiros.

Ahora aquí descansa
sobre mi mesa y frente
a las aguas de marzo.

Ya vuelve

half-closed, dark,
with ivy tied
to the sunset),
(and a kiss
hard as a
stone that attacks),
then
between one mouth and the other,
the eternal
sea,
the archipelago,
the necklace of
islands
and the ships
besieged
by the cold,
awaiting
the blue animal
from the southern
depths
of the ocean,
the animal born
of the deluge
with its hardware
of sapphires.

Now it rests
on my table, facing
the waters of March.

Returning now
to the sandy lap of the coast,
the steam of autumn, the lost
lamp,
the heart of the fog.

al regazo arenoso de la costa,
el vapor del otoño, la lámpara
perdida,
el corazón de niebla.
Y el diente de la bestia,
tatuado por los dedos delicados
del amor,
es la mínima nave
de marfil que regresa.

 Ya las vidas

del hombre y sus amores,
su arpón sangriento, todo
lo que fue carne y sal, aroma y oro,
para el desconocido marinero
en el mar de la muerte se hizo
polvo.
Y sólo de su vida
quedó el dibujo
hecho
por el amor
en el diente terrible
y el mar, el mar
latiendo
igual que ayer, abriendo
su abanico de hierro,
desatando y atando
la rosa sumergida
de su espuma,
el desafío
de su vaivén eterno.

And the beast's tooth,
tattooed by the delicate fingers
of love,
is the tiny ship
of ivory returning.
 Now the lives
of man and his loves,
his bloody harpoon, all
that was flesh and salt, aroma and gold,
has turned to dust for the unknown sailor,
into the sea of death.
And all that remains of his life
is the sketch
made
by love
on the terrible tooth
and the sea, the sea
throbbing
just like yesterday, opening
its fan of iron,
untying and tying
the submerged rose
of its foam,
the challenge
of its eternal swaying to and fro.

La Medusa. I

Me ocultaron en Valparaíso. Eran días turbulentos y mi poesía andaba por la calle. Tal cosa molestó al Siniestro, Pidió mi cabeza.

Era en los cerros del Puerto. Los muchachos llegaban por la tarde. Marineros sin barco. Qué vieron en la rada? Van a contármelo todo.

Porque yo, desde mi escondrijo, no podía mirar sino a través de medio cristal de la empinada ventana. Daba sobre un callejón, allá abajo.

La noticia fue que una vieja nave se estaba desguazando. No tendrá una figura en la proa?, pregunté con ansiedad.

Claro que tiene una mona, me dijeron los muchachos. Una mona o un mono es para los chilenos la denominación de una estatua imprecisa.

Desde ese momento dirigí las faenas desde la sombra. Como costaba gran trabajo desclavarla, se la darían a quien se la llevara.

Pero la Mascarona debía seguir mi destino. Era muy grande y había que esconderla. Dónde? Por fin, los muchachos hallaron una barraca anónima y extensa. Allí se la sepultó en un rincón mientras yo cruzaba a caballo las cordilleras.

Cuando volví del destierro, años después, habían vendido la barraca (con mi amiga, tal vez). La buscamos. Estaba honestamente erigida, en un jardín de tierra adentro. Ya nadie sabía de quién era ni quién era.

Costó tanto trabajo sacarla del jardín como del mar. Solimano me la llevó una mañana en un inmenso camión. Con esfuerzo la descargamos y la dejamos inclinada frente al océano en la puntilla, sobre el banco de piedra.

The Medusa. I

They hid me in Valparaiso. Those were turbulent days and my poetry circulated in the street. This disturbed the Sinister One. He demanded my head.

It was in the hills above the port. The boys arrived during the afternoon. Sailors without a ship. What had they seen in the harbor? They would tell me everything.

From my hiding place, I could see only through the glass medium of the lofty window. It looked out over an alley.

The news was that an old ship had broken down. Does it have a figurehead on the prow? I anxiously asked.

Of course, it has a *mona*, the boys said. A mona, or mono, which in ordinary Spanish is a monkey, is for Chileans the term for any kind of statue.

From that moment on I directed the activities from the shadows. Since it was very difficult to take her down, she would be given to whoever carried her off.

But the figurehead was to share my destiny. She was very large, and she had to be hidden. Where? At last, the boys found an anonymous and spacious shed. There she was buried in a corner while I crossed the mountains on horseback.

When I came back from exile, years later, the shed had been sold (perhaps along with my lady-friend). We searched for her. She was proudly erected in someone's garden inland. No one any longer knew whose she was or what she was.

It was as hard to take her out of the garden as it had been to take her out of the sea. Solimano brought her to me one morning in an immense truck. With great effort we unloaded her and left her leaning on the stone bench with her face to the ocean.

I didn't know her. I had directed the entire operation

Yo no la conocía. Toda la operación del desguace la
precisé desde mis tinieblas. Luego nos separó la violencia, más
tarde, la tierra.

Ahora, la vi, cubierta de tantas capas de pintura que
no se advertían ni orejas ni nariz. Era, sí, majestuosa en su
túnica volante. Me recordó a Gabriela Mistral, cuando, muy
niño, la conocí en Temuco, y paseaba, desde el moño hasta los
zapatones, envuelta en paramentos franciscanos.

on the wreck from my darkness. Then violence separated us; later, the land did.

Now I saw her, covered with so many coats of paint that neither the ears nor the nose could be seen. She certainly was majestic in her flowing tunic. She reminded me of Gabriela Mistral, when I, a small child, met her in Temuco, when she would walk around wrapped in Franciscan robes from her topknot to her overshoes.

La Medusa. II

"La Medusa" se quedó pues con ojos al noroeste y el cuerpo grande se dispuso como en su proa, inclinado sobre el océano. Así, tan bien dispuesta, la retrataron los turistas de verano y se las arreglaba para tener con frecuencia un pájaro sobre la cabeza, gaviotín errante, tórtola pasajera. Nos habituamos todos los de casa, agregándose también Homero Arce, a quien dicté muchas veces mis renglones bajo la frente cenicienta de la estatua.

Pero comenzaron las velas. Encontramos a las beatas del caserío muy arrodilladas, rezándole al aventurero mascarón.

Y por la tarde le encendían velas que el viento, antiguo conocedor de santos, apagaba con indiferencia.

Era demasiado: Desde la bahía de Valparaíso, en compañía continua de marineros y cargadores, haciendo vida ilegal en el subterráneo político de la patria hasta ser Pomona de Jardín, sacerdotisa sonora y ahora santísima sectaria. Porque como de cuanto pasa en Chile me echan a mí la culpa, me habrían colgado luego la fundación de una nueva herejía.

Disuadimos, Matilde y yo, a las devotas contándoles la historia privada de aquella mujer de madera, y las persuadimos de no seguir encendiéndole velas que además podrían incendiar a la pecadora.

Pero por fin, contra las amenazas del cerote que ensucia, de las llamas que incineran y de la lluvia que pudre, llevamos a Medusa adentro. La dispusimos en el coro de los mascarones.

Vivió una vez más. Porque al sacarla con formón y gubia retiramos una pulgada de pintura gruesa y grosera que la escondía y salió a relucir su perfil decidido, sus exquisitas orejas, un medallón que nunca se le divisó siquiera y una cabellera

The Medusa II

"The Medusa" remained with her eyes pointed northwest and her large body arranged as on the prow of her ship, leaning out over the ocean. Like that, so well positioned, she was photographed by the summer tourists, and she managed frequently to have a bird on her head, a wandering tern, a passing turtledove. All of us in the house, including Homero Arce, to whom I often dictated my verses beneath the ashen brow of the statue, grew accustomed to her.

But then the candles started. We found the devout women of the village kneeling, praying to the adventurous figurehead. And in the afternoon they lit candles to her, which the wind, an old connoisseur of saints, would extinguish with indifference.

It was too much: From the harbor of Valparaiso, the constant company of sailors and longshoremen, to an illegal life in the political underground of the homeland, to end as a garden ornament, a sonorous priestess and now most holy sanctuary. Since I get blamed for everything that happens in Chile, they would have pinned the founding of a new heresy on me.

Matilde and I dissuaded the devout, telling them the private story of that wooden woman, and we persuaded them not to keep lighting candles to her, candles which besides could set fire to the sinner.

But at last, against the menace of the wax that dirties, the flames that incinerate and the rain that rots, we carried Medusa inside. We set her up in the figurehead choir.

She came to life once more. When we took her inside, with chisels and gouges we stripped away an inch of the thick, disgusting paint that hid her, and one could see her decisive

selvática que cubre su clara cabeza como el follaje de un árbol petrificado que aún recuerda su pajarerío.

profile, her exquisite ears, a medallion that no one had ever noticed, and a jungle of hair that covered her bright head like the foliage of some petrified tree that still remembers flocks of birds.

El Armador

No sabían que era mascarón, tan lejos se apartó del bauprés ancestral. Porque me dijeron en Venezuela que hizo de busto monumental de Padre de la Patria. Luego rodó por los patios de un colegio, centro de travesuras y blanco de los alborotos.

Yo, apenas lo vi, ensimismado y perdido entre la iconografía, comprendí de inmediato su origen marinero. La orla de la ola no dejaba duda, esa voluta de agua que el artesano siempre dejó a la vera del conductor de proa. También el mar y un piedrazo de colegial, con ruptura de nariz, le acentuó el romántico rostro tan parecido a Pushkin. Entre héroe o poeta, no podía ser sino armador, naviero allí tallado por su propia empresa y luego aureolado por la ráfaga.

Los poetas reunidos en Caracas me lo dieron con una ceremonia que recuerdo porque tintineaban las copas y la poesía venezolana estrellaba la noche del jardín.

The Shipwright

They didn't know it was a figurehead; it had come so far from its ancestral bowsprit. In Venezuela, I was told, it had served as the monumental bust of the Father of the Country. Later it passed through the courtyards of some high school, the butt of pranks and target of disturbances.

As soon as I saw it, I, absorbed in thought and lost in the iconography, understood immediately its maritime origin. The edge of the wave left no doubt, that scroll of water which the artisan always left at the side of the prow guide. Also the sea, and its nose, broken by a stone thrown by a schoolboy, accentuated the romantic face so similar to that of Pushkin. Somewhere between a hero or a poet, it had to have been a shipwright or ship owner, carved there through his own enterprise and later glorified by the wind.

The poets gathered in Caracas gave it to me with a ceremony that I remember because the glasses were clinking and Venezuelan poetry shattered the night in the garden.

Ceremonia

En el año 1847 un navío norteamericano, el *Clipper
Cymbelina, debió recalar en una caleta sin nombre del Norte de
Chile. Allí los hombres de mar procedieron a desclavar el
mascarón de proa del velero. Esta estatua blanca y dorada
parecía ser una novia muy joven ceñida por un ropaje isabelino.
El rostro de aquella niña de madera asombraba por su
desgarradora belleza. Los marineros del* Cymbelina *se habían
amotinado. Sostenían que el Mascarón de Proa movía los ojos
durante el viaje, desorientando el derrotero y aterrorizando a la
tripulación.*

*No es cosa fácil destronar a la rectora de un viejo y
férreo navío. Pero, llevados por aquel religioso terror, los
marineros aserraron el poderoso perno que la aseguraba al
bauprés, cortaron clavos y tornillos hasta que pudieron, no sin
cierto temor o respeto, descenderla y colocarla en una lancha
que los llevó a la playa.*

*El mar estaba agitado aquel día de julio. Era pleno
invierno y una lluvia grave y lentísima, extraña en aquella
desértica región, caía sobre el mundo.*

*Siete hombres de a bordo levantaron en hombros a la
niña de madera insólitamente separada de su nave. Luego
cavaron una fosa en la arena. Los guanayes, aves estercorarias de
la costa, volaban en círculo, graznaban y chillaban mientras
duró la inquietante faena. La extendieron en tierra, la cubrieron
con la arena salitrosa del desierto. No se sabe si alguno de los
enterradores quiso rezar o sintió alguna repentina racha de
arrepentimiento y tristeza. La garuga, lenta lluvia nortina que
oscila entre niebla o fantasmagoría, cubrió pronto la ribera del
mar, los amarillos acantilados y la embarcación que en el gran
silencio retornó con los hombres de mar al velero* Cymbelina *en
aquella mañana del mes de julio de 1847.*

Ceremony

In 1847 an American vessel, the clipper *Cymbelina*, landed in some nameless cove in northern Chile. There the men of the sea proceeded to take down the figurehead from the prow of the sailing vessel. This white-and-gold statue seemed to be a very young bride garbed in Elizabethan costume. The face of that wooden girl was astonishing because of its wrenching beauty. The seamen of the *Cymbelina* had mutinied. They maintained that the prow figurehead moved its eyes during the voyage, putting them off course and terrifying the crew.

It is not an easy thing to dethrone the queen of a tough, old vessel. But, impelled by that religious terror, the sailors sawed through the powerful bolt that fastened her to the bowsprit, cut through nails and screws until they were able, not without certain fear or respect, to lower it and place her in a launch that carried them to shore.

The sea was choppy that July day. It was the middle of winter, and a heavy, slow rain, strange in that desertlike region, was falling on the world.

Seven crewmen carried on their shoulders the wooden girl strangely separated from her ship. Then they dug a ditch in the sand. The *guanayes*, stercoraceous coastal birds, were flying in circles, cawing and shrieking while the unsettling chore lasted. They laid her on the ground and covered her with the nitrous sand of the desert. It isn't known if any of the men who buried her attempted to pray or felt some sudden pang of regret or sadness. The *garuga*, a slow rain borne on the north wind that oscillates between fog and phantasmagoria, soon covered the seashore, the yellow cliffs, and the boat which in the great silence brought the seafarers back to the sailing ship *Cymbelina* on that morning in July 1847.

El Gran Jefe Comanche

No sé cómo pudo entrar su colosal estatura y el carcaj amenazante. Aquí llegó y domina por sus plumas, por el indomable perfil, por la dureza de sequoia roja que resistió el oleaje férreo.

Un piel roja de navío ballenero, de Massachusetts, como el que tal vez guiaba el barco del joven Melville por los puertos peruanos y chilenos. Pues es sabido que fue estatua preferida de los perseguidores de ballenas. Y los artesanos de Nantucket los esculpieron más de una vez. Cuando sobrevino el vapor y fueron olvidados los veleros, los viejos artesanos siguieron tallando este Piel Roja, convertido en insignia de farmacia o de cigarrería. (Aquellas "Boticas del Indio" con aroma de cien raíces, cuando el alquímico practicaba ungüentos y obleas con morteros y delicadeza!)

Lo cierto es que nunca desarrugó el ceño: que con arco, hacha, cuchillón y ademán es el valiente entre mis desarmadas doncellas del mar. Ni Búffalo Bill con sus andanadas de pólvora ni el océano lleno de monstruos recalcitrantes pudo alterar su poderío. Aquí sigue intacto y duro.

Big Chief
of the Comanches

I don't know how that colossal stature and the menacing quiver were able to get inside. But here it is, and lords it over the others, because of its feathers, its indomitable profile, and the hardness of its sequoia redwood that withstood the fierce tides.

A Redskin from a whaling vessel out of Massachusetts, like the one that may have guided young Melville's ship through the Peruvian and Chilean ports. It is known that it was the favorite statue of the whale hunters, and the artisans of Nantucket sculpted more than one. With the advent of the steam engine, when sailing ships were forgotten, the old artisans continued to carve this Redskin, converted into the insignia for a pharmacy or cigar store. (Those "Indian drugstores" with their aroma of a hundred roots, where alchemists prepared ointments and pills with mortars and with delicacy!)

The truth is that he never unfurrowed his brow; that with his bow, tomahawk, knife and gesture he is the brave one among my unarmed sea-maidens. Not even Buffalo Bill with his fusillades of gunpowder, nor the ocean filled with recalcitrant monsters could lessen his power. Here he remains intact and tough.

La Sirena

Fue en el extremo Sur, donde Chile se desgrana y se
desgrana. Los archipiélagos, los canales, el territorio
entrecortado, los ciclones de la Patagonia, y luego
el Mar Antártico.

Allí la encontré: colgaba del pontón pútrido,
grasiento, enhollinado. Y era patética aquella diosa en la lluvia
fría, allí en el fin de la tierra.

Entre chubascos la libertamos del territorio austral. A
tiempo, porque algún año después el pontón se fue con el
maremoto a la profundidad o al mismo infierno. Aquél, cuando
fue nave, se llamó Sirena. Por eso ella conserva su nombre de
Sirena. Sirena de Glasgow. No es tan vieja. Salió del astillero en
1886. Terminó transportando carbón entre las barcas del Sur.

Sin embargo, cuánta vida y océano, cuánto tiempo y
fatiga, cuántas olas y cuántas muertes hasta llegar al
desamparado puerto del maremoto! Pero también, a mi vida.

The Mermaid

It was in the extreme south, where Chile crumbles into pieces. The archipelagos, the channels, the broken territory, the cyclones from Patagonia, and then the Antarctic Sea.

There I found her: she was hanging from a rotted, greasy, soot-covered hulk. And that goddess was pathetic in the cold rain, there at the end of the earth.

In the midst of squalls, we freed her from the southern territory. Just in time, because one year later the hulk went down to the deep or to hell, itself with the tidal bore. That hulk, when it was a seagoing vessel, was called *Mermaid*. For that reason she is named Mermaid. The Glasgow Mermaid. She was not very old. She came out of the shipyards in 1886. She ended up transporting coal with the barges of the South.

Nevertheless, how much life and ocean, how much time and fatigue, how many waves and how many deaths before she came to that foresaken bay of the tidal wave! But also, into my life.

La Maria Celeste

Alain y yo la sacamos del mercado de las Pulgas donde yacía bajo siete capas de olvido. En verdad costaba trabajo divisarla entre camas desmanteladas, fierros torcidos. La llevamos en aquel coche de Alain, encima, amarrada, y luego en un cajón, tardando mucho, llegó a Puerto San Antonio. Solimano la rescató de la aduana, invicta, y me la trajo hasta Isla Negra.

Pero yo la había olvidado. O tal vez conservé el recuerdo de aquella aparición polvorienta entre la "ferraille". Sólo cuando destaparon la pequeña caja sentimos el asombro de su imponderable presencia.

Fue hecha de madera oscura y tan perfectamente dulce! Y se la lleva el viento que levanta su túnica! Y entre la juventud de sus senos un broche le resguarda el escote. Tiene dos ojos ansiosos en la cabeza levantada contra el aire. Durante el largo invierno de Isla Negra algunas misteriosas lágrimas caen de sus ojos de cristal y se quedan por sus mejillas, sin caer. La humedad concentrada, dicen los escepticistas. Un milagro, digo yo, con respeto. No le seco sus lágrimas, que no son muchas, pero que como topacios le brillan en el rostro. No se las seco porque me acostumbré a su llanto, tan escondido y recatado, como si no debiera advertirse. Y luego pasan los meses fríos, llega el sol, y el dulce rostro de María Celeste sonríe suave como la primavera.

Pero, por qué llora?

82

The Marie Celeste

Alain and I got her at the flea market where she lay under seven layers of oblivion. She really was hard to catch sight of among dilapidated beds and twisted bars of iron. We took her away in that car of Alain's, on top, tied down, and later in a large box, proceeding very slowly, she arrived at Puerto San Antonio. Solimano rescued her from the customs office, unconquered, and brought her to me at Isla Negra.

But I had forgotten about her. Or perhaps I kept my memory of that dusty apparition on the scrap heap. Only when the small box was opened did we feel the astonishment of her imponderable presence.

She is made of dark wood. Perfect! Sweet! And she is carried on the wind, which lifts her robe! And between her youthful breasts a brooch shields her low neckline. She has two anxious eyes on that head raised against the air. During the long winter of Isla Negra some mysterious tears fall from her crystal eyes and remain on her cheeks, without falling. Concentrated dampness, say the skeptics. A miracle, say I, with respect. I don't dry her tears, which are not plentiful but which shine like topazes on her face. I don't dry them because I have become accustomed to her tears, so well hidden and circumspect they shouldn't be noticed. And then the cold months pass, the sun arrives, and Marie Celeste's sweet face smiles softly like the spring.

But why does she cry?

La Novia

Es la más amada por más dolorosa.

La intemperie le rompió la piel en fragmentos o cáscaras o pétalos. Le agrietó el rostro. Le rompió las manos. Le trizó los redondos acariciados hombros. Acariciados por la borrasca y por el viaje.

Quedó como salpicada por las mil espumas. Su noble rostro agrietado se convirtió en una máscara de plata combatida y quemada por la tempestad glacial. El recogimiento la envolvió en una red de cenizas, en un enjambre de nieblas.

The Bride

She is the most beloved because she is the most sorrowful.

The elements tore her skin into fragments, or peeling bark, or petals. They cracked her face. They broke her hands. They tore to pieces her shoulders so round and so caressed. Caressed by the tempest and the voyage.

She was left spattered by a thousand specks of foam. Her noble, split face became a silver mask fought and burned by the glacial tempests. Confinement envelops her in a web of ashes, in a swarm of fogs.

La Cymbelina

*Oh novia Cymbelina, pura purísima, suavísima suave!
Oh tú, doncella de mantilla y nariz rota! Oh sueño de la nave
turbulenta, rosa de sal, naranja clara, nenúfar!*

*Cuando me condujeron a aquella casa donde no me
esperaban, algo me hizo volver y mirar aquella casa desierta por
el ojo de la llave. Y allí, en el hueco, encontré por vez primera
tu perfil errante. Juré que volverías al mar, al mar de Isla Negra.*

*Rondé por las afueras de la casa, expulsado por el
propietario feudal como si hubiera sido un malhechor. Él
recurrió a la astucia y a la fuerza. Mis cartas de amor fueron
devueltas, los regalos con que intenté sobornar al egoísta,
fueron rechazados.*

*Mis amados secuaces Pedregala y Matazán lo asediaron,
entraron a saco en la mansión, descuartizaron centinelas,
pulverizaron vitrinas y a fuerza de artillería y blasfemias
rescataron a la nevada Cymbelina. Aquellas hazañas aún se
cuentan en las bodegas de Valparaíso.*

*Mírala tú, antes de que la luz o la noche se la lleven.
Marinera del cielo, aún no se acostumbra a la tierra. En siglos
de viaje perdió fragmentos, recibió golpes, acumuló hendiduras,
sobrevivió fragante. La edad marina, el transcurso, la estrellada
soledad, las olas bruscas, los combates acérrimos, le infundieron
una mirada perdida, un corazón sin recuerdos. Es pura noche,
pura distancia, pura rosa y claridad sosegada, virtud celeste.*

*Nunca se sabe si volará o navegará de pronto, sin
aviso, circulando en su noche o en su nave, estampada como
una paloma en el viento.*

Cymbelina

Oh, bride Cymbelina, most pure, most gentle! Oh, you, maiden with shawl and broken nose! Oh dream of the turbulent ship, rose of salt, bright orange, water lily!

When they took me to that house in which no one expected me, something made me turn and look into the deserted house through the keyhole. And there, in the opening, I found for the first time your wandering profile. I swore you would return to the sea, to the sea of Isla Negra.

I walked up and down before your house, kept out by the feudal proprietor as though I were a criminal. He had recourse to cunning and to force. My love letters were returned; the gifts with which I intended to bribe the selfish man were rejected.

My beloved followers, Pedregala and Matazán, besieged him, entered the mansion to plunder, cut the sentinels to pieces, pulverized glass showcases, and by means of artillery and blasphemies rescued the snow-white Cymbelina. Those deeds of daring are still recounted in the wine shops of Valparaiso.

Look at her, before the light or the night carries her off. Sailor-maiden of heaven, she is still unaccustomed to earth. In centuries of voyage she lost fragments, received blows, accumulated cracks, survived fragrantly. Her years at sea, the course of time, the star-spangled solitude, the rough wave, the bitter battles, infused her with a vacant stare, a heart without memories. She is pure night, pure distance, pure rose and calm clarity, celestial virtue.

One never knows whether she will suddenly fly or sail, without warning, circulating in her night or in her ship, engraved like a dove on the wind.

*(Nota: Descubrí entre tanto que era ella. Cymbelina,
la que hacía cambiar de rumbo al navío. Fue ella la enterrada
en la arena.)*

(Note: I discovered meanwhile that it was she,
Cymbelina, who made the ship change course. She was the one
buried in the sand.)

La Bonita

No sólo se *llamó* La Bonita *la barcaza sino que, ya
desmantelada, cogida por las ventoleras del Estrecho, pasó a ser,
siempre bella, juguete de tempestades y desventuras. Las
costillas del barco pudieron mantenerse por años después del
naufragio, pero la Figura de Proa se desmembró a pedazos. Las
grandes olas la atacaron y las vestiduras se peridieron, fueron
exterminados los brazos y los dedos, hasta que por milagro, se
sostuvo aquella solitaria cabeza, como empalada, en el último
orgullo de la proa.*

*Allí, en un mediodía apaciguado, la encontraron las
manos rapaces. Anduvo así, de manos en manos.*

*Pero por aquel rostro no había pasado nada. Ni la
guerra del mar, ni el naufragio, ni la soledad tempestuosa de
Magallanes, ni la ventisca que muerde con dientes de nieve. No.*

*Se quedó con su rostro impertérrito, con sus facciones
de muñeca, vacía de corazón.*

*La hicieron lámpara de vestíbulo y la encontré por
primera vez bajo una horrible pantalla de rayón, con la misma
sonrisa que nunca comprendió la desdicha. hasta una oreja, que
la tempestad no destruyó, mostraba el lóbulo quemado por la
corriente elétrica. Lleno de ira le hice volar el sombrero barato
que parecía satisfacerla, la libré de su electrificación ignominiosa
para que siguiera mirándome como si no hubiera pasado nada,
tan bonita como antes de naufragar en el mar y en
los vestíbulos.*

Beauty

Not only was the barge called "Beauty" but, once dilapidated, seized by the blasts of wind from the Straits, it went on to become, still beautiful, a plaything for tempests and misfortunes. The ribs of the ship managed to remain firm for years after the shipwreck, but the figurehead shattered into pieces. The great waves attacked her and her clothing was lost, her arms and fingers exterminated, until miraculously, that solitary head, as though impaled, stayed erect in the prow's last pride.

There, on a peaceful noon rapacious hands found her. She went along in that way, from hand to hand.

But nothing had happened to the face. Not the struggle with the sea, nor the shipwreck, nor the tempest-tossed solitude of the Straits of Magellan, nor the blizzard that bites with teeth of snow. No.

She remained with her dauntless face, with her doll features, vacant of heart.

They turned her into a hall light, and I found her for the first time under a horrible, rayon lamp shade, with the same smile that never comprehended misfortune. Even one ear, which the tempest did not destroy, showed a lobe burned by electric current. Full of wrath I sent flying the cheap hat that seemed to satisfy her; I liberated her from her ignominious electrification so that she could continue to gaze at me as though nothing had happened, as pretty as before going down at sea and in hallways.

La Micaela

La última en llegar a mi casa (1964) fue la Micaela.
Es corpulenta, segura de sí misma, de brazos colosales.
Estuvo después de sus travesías, dispuesta en un jardín, entre las chacarerías. Allí perdió su condición navegativa, se despojó del enigma que ciertamente tuvo (porque lo trajo de los embarcaderos) y se transformó en terrestre pura, en mascarona agrícola. Parece llevar en sus brazos alzados no el regalo del crepúsculo marino sino una brazada de manzanas y repollos. Es silvestre.

Micaela

The last one to arrive at my home (1964) was Micaela.
She is corpulent, sure of herself, with colossal arms. After her
sea crossings, she was set up in a garden, among the farmlands.
There she lost her maritime condition, was stripped of the
mystery she certainly had (because she was brought from the
wharves), and was transformed into a purely terrestrial being,
into an agricultural figurehead. She appears to carry in her
raised arms not the gift of the twilight at sea but an armful of
apples and cabbages. She is rustic.

La Bandera

Mi bandera es azul y tiene un pez horizontal que encierran o desencierran dos círculos armilares. En invierno, con mucho viento y nadie por estos andurriales, me gusta oír la bandera restallando y el pescado nadando en el cielo como si viviera.

Y por qué ese pez, me preguntan. Es místico? Sí, les digo, es el simbólico ictiomin, el precristense, el cisternario, el lucicrático, el fritango, el verdadero, el frito, el pescado frito.

—Y nada más?

—Nada más.

Pero en el alto invierno allá arriba se debate la bandera con su pez en el aire temblando de frío, de viento de cielo.

The Flag

My flag is blue and sports a horizontal fish enclosed or released by two armillary spheres. In the winter when the wind blows hard and no one is around in these parts, I like to hear the flag flapping and the fish swimming in the sky as if it were alive.

And why this fish, you ask. Is it mystical? Yes, I tell you, it is the ichthyic symbol, the pre-Christian, the cisternal, the lucicratic, the fry, the genuine, the fritter, the fried fish.

And nothing else?

Nothing else.

But in midwinter the flag thrashes up there with its fish in the air trembling with cold, with wind, and with sky.

El Ancla

El ancla llegó de Antofagasta. De algún barco muy grande, de aquellos que cargaban salitre hacia todos los mares. Allí estaba durmiendo en los áridos arenales del Norte grande. Un día se le ocurrió a alguien mandármela. Con toda su grandeza y su peso fue un viaje difícil, de camión a grúa, de barco a tren, a puerto, a barco. Cuando llegó a mi puerta no quiso moverse más. Trajeron un tractor. El ancla no cedió. Trajeron cuatro bueyes. Estos la arrastraron en una corta carrera frenética, y entonces sí se movió, hasta quedarse reclinada entre las plantas de la arena.

—La pintarás? Se está oxidando.

No importa. Es poderosa y callada como si continuara en su nave y no la desgañitara el viento corrosivo. Me gusta esa escoria que la va recubriendo con infinitas escamas de hierro anaranjado.

Cada uno envejece a su manera y el ancla se sostiene en la soledad como en su nave, con dignidad. Apenas si se le va notando en los brazos el hierro deshojado.

The Anchor

The anchor arrived from Antofagasta. From some very large ship, the kind that hauls potassium nitrate across the seven seas. It was sleeping there in the arid sands of the great North. One day it occurred to someone to send it to me. With its great size and weight it was a difficult voyage, from truck to crane, from ship to train, to harbor, to ship. When it arrived at my door, it refused to move any further. They brought a tractor. The anchor didn't budge. They brought several oxen, which dragged it along in a short, frantic run, and then it did move, to remain leaning against the plants in the sand.

"Will you paint it? It's rusting."

It doesn't matter. It is powerful and silent as though it were still on its vessel and the corrosive wind was not attacking it in all its fury. I like the dross that little by little is covering it with infinite scales of orange iron.

Everyone ages in his or her own way, and the anchor bears up in solitude as it did on its vessel, with dignity. One hardly notes the flaked-off iron on its arms.

El Locomovil

Tan poderoso, tan triguero, tan procreador y silbador y rugidor y tronador! Trilló cereales, aventó aserrín, taló bosques, aserró durmientes, cortó tablones, echó humo, grasa, chispas, fuego, dando pitazos que estremecían las praderas.

Lo quiero porque se parece a Walt Whitman.

The Locomotive

So powerful, so associated with wheat, so productive and whistling and roaring and thundering! It threshed cereals, it scattered sawdust to the winds, it felled trees, sawed cross-ties, cut boards, gave off smoke, grease, sparks, fire, while whistling shrilly enough to make the meadows tremble.

I love it because it resembles Walt Whitman.

Amor
Para Este Libro

En estas soledades he sido poderoso
de la misma manera que una herramienta alegre
o como hierba impune que suelta sus espigas
o como un perro que se revuelca en el rocío.
Matilde, el tiempo pasará gastando y encendiendo
otra piel, otras uñas, otros ojos, y entonces
el alga que azotaba nuestras piedras bravías,
la ola que construye, sin cesar, su blancura,
todo tendrá firmeza sin nosotros,
todo estará dispuesto para los nuevos días,

Qué dejamos aquí sino el grito perdido
que no conocerán nuestro destino
del queltehue, en la arena del invierno, en la racha
que nos cortó la cara y nos mantuvo
erguidos en la luz de la pureza,
como en el corazón de una estrella preclara?

Qué dejamos viviendo como un nido
de ásperas aves, vivas, entre los matorrales
o estáticas, encima de los fríos peñascos?
Así, pues, si vivir fue sólo anticiparse
a la tierra, a este suelo y su aspereza
líbrame tú, amor mío, de no cumplir, y ayúdame
a volver a mi puesto bajo la tierra hambrienta.

Pedimos al océano su rosa,

Love
For This Book

In these lonely regions I have been powerful
in the same way as a cheerful tool
or like untrammeled grass which lets loose its seed
or like a dog rolling around in the dew.
Matilde, time will pass wearing out and burning
another skin, other fingernails, other eyes, and then
the algae that lashed our wild rocks,
the waves that unceasingly construct their own whiteness,
all will be firm without us,
all will be ready for the new days,
which will not know our destiny.

What do we leave here but the lost cry
of the seabird, in the sand of winter, in the gusts of wind
that cut our faces and kept us
erect in the light of purity,
as in the heart of an illustrious star?

What do we leave, living like a nest
of surly birds, alive, among the thickets
or static, perched on the frigid cliffs?
So then, if living was nothing more than anticipating
the earth, this soil and its harshness,
deliver me, my love, from not doing my duty, and help me
return to my place beneath the hungry earth.

We asked the ocean for its rose,

su estrella abierta, su contacto amargo,
y al agobiado, al ser hermano, al herido
dimos la libertad recogida en el viento.
Es tarde ya. Tal vez
sólo fue un largo día color de miel y azul,
tal vez sólo una noche, como el párpado
de una grave mirada que abarcó
la medida del mar que nos rodeaba,
y en este territorio fundamos sólo un beso,
sólo inasible amor que aquí se quedará
vagando entre la espuma del mar y las raíces.

its open star, its bitter contact,
and to the overburdened, to the fellow human being,
 to the wounded
we gave the freedom gathered in the wind.
It's late now. Perhaps
it was only a long day the color of honey and blue,
perhaps only a night, like the eyelid
of a grave look that encompassed
the measure of the sea that surrounded us,
and in this territory we found only a kiss,
only ungraspable love that will remain here
wandering among the sea foam and the roots.

El Mar

 El mar retumba como un combate antiguo. Qué acarrea allá abajo? Tomates, toneles, toneladas de truenos, torres y tambores. Cuando estremece sus ferreterías se estremece mi casa. La noche se sacude, el sonido alcanza un oscuro paroxismo en que ya no sabemos nada, en el entresueño, en la espesura del apogeo tempestuoso, despertando a destiempo cuando ya el golpe de aquella ola gigante se fue por la arena y se convirtió en silencio.

The Sea

The sea resounds like an ancient battle. What does it drag along down there? Tomatoes, barrels, tons of thunder, towers, and drums. When it makes its hardware tremble, my house trembles. The night shakes, the sound reaches a dark paroxysm in which we no longer know anything, in the state between sleep and waking, in the thickness of the tempestuous apex, awakening inopportunely when the blow of that giant wave already rushed away along the sand and turned into silence.

El Mar

 Lo inquietante es la gran barriga azul, grávida y grave, que se mece, despaciosa, que no viene ni va ni ataca ni acecha.
 Qué va a nacer?, pregunta el hombre a la tranquilidad redonda. Y poco a poco va meciéndose y durmiéndose, metido una vez más en la cuna terrible.

The Sea

What's disturbing is the great blue, full and solemn belly, which rocks to and fro, slowly, which does not come or go, attack or lie in wait.

"What is going to be born?" the man asks of the tranquil roundness. And little by little it goes along rocking and falling asleep, once more ensconced in the terrible cradle.

El Mar

Me rodea el mar, me invade el mar: somos salobres,
mesa mía, pantalones míos, alma mía: nos convertimos en sal.
No sabemos qué hacer en las calles, entre la gente apresurada,
en las boticas, en el baile, perdimos las costumbres, las palabras
en clave para comprar y vender. Nuestra mercadería fueron algas
relucientes serpentinas o foliáceas, pétalos enyodados, mariscos
sangrientos. La sal de la espuma nos chisporroteó de tal manera,
la sal del aire nos impregnó como si fuéramos una casa perdida,
hasta que circuló sólo salmuera en las habitaciones.

The Sea

I am surrounded by the sea, invaded by the sea; we
are salty, oh, table of mine, pants of mine, soul of mine; we are
turning into salt. We don't know what to do in the streets,
among the hurrying people, in the drugstores, at the dance, we
are losing the customs, the code words for buying and selling.
Our merchandise is gleaming algae, serpentine or with fronds,
petals, petals soaked in iodine, bloody crustaceans. The salt
from the foam splattered us in such a way that the salt in the
air impregnated us as though we were a lost house, until only
brine circulated in the rooms.

El Mar

La sal de siete leguas, la sal horizontal, la sal cristalina del rectángulo, la sal borrascosa, la sal de siete mares, la sal.

The Sea

The salt of seven leagues, horizontal salt, crystalline
salt of the rectangle, stormy salt, the salt of the seven seas, salt.

El Mar

Este cerco, esta puerta hacia lo ilimitado, y por qué?

Heredamos los cercos, los candados, los muros, las prisiones.

Heredamos los límites. Y por qué?

Por qué no rechazamos a la hora de nacer cuanto nos concedían y cuanto no abarcábamos? Es que teníamos que estar de acuerdo antes de ser. Después de ser y saber se aprende a cercar y a cerrar. Nuestra mezquina contribución al mundo es un mundo más estrecho.

The Sea

This fence, this gateway toward the limitless, and why?

We inherit fences, padlocks, walls, prisons.

We inherit limits. And why?

Why didn't we reject, at birth, everything granted to us and everything we did not include? The fact is that we had to agree before being. After being and knowing one learns to fence in and to close up. Our wretched contribution to the world is a narrower world.

El Mar

Este pobre cerco sólo fue edificado para que mis dos perros—Panda y Yufú—no se escaparan a matar ovejas en las tierras de los sacerdotes. Estos tienen rebaños aquí cerca, en Punta de Tralca, junto al más alto peñasco de la costa. Mis ancestrales perros descubrieron las ovejas, y esto nos pareció peligroso y salvaje.

Ahora las hierbas de la orilla. alimentadas de rocío salado, suben por los palos viejos. Los que se blanquearon como huesos de ballena v se debilitaron al golpe del viento férreo. No sirve para nada el viejo cerco. De este lado mis ojos se abren hacia el circundante infinito.

The Sea

This poor fence was constructed only so that my two dogs—Panda and Yufu—would not escape to kill sheep on the priests' lands. The priests have flocks nearby, in Punta de Tralca, next to the highest cliff on the coast. My atavistic hounds discovered the sheep, and this seemed to us to be dangerous and savage.

Now the grasses at the shore, nourished by salty dew, climb up along the old sticks of wood, bleached like whale bones and weakened by the blows of the strong wind. The old fence is good for nothing. From this side of it, my eyes open to the surrounding infinity.

El Mar

Más allá de estos barrotes inútiles, el mar que de verdad no sabe que está circunscrito, y no lo reconoce, cantando. Su ímpetu es amargo, su canto es estruendo. Su espuma revolucionaria me cuenta y estalla, me cuenta y se desploma, me llama y ya se fue.

Canta y golpea el mar, no está de acuerdo. No lo amarren. No lo encierren. Aún está naciendo. Estalla el agua en la piedra y se abren por vez primera sus infinitos ojos. Pero se cierran otra vez, no para morir, sino para seguir naciendo.

The Sea

Beyond these useless bars, the sea, which really doesn't know it is circumscribed, and doesn't recognize it, is singing. Its violence is bitter; its song is a crashing sound. Its revolutionary foam speaks to me and explodes, speaks to me and collapses, calls to me and is already gone.

The sea sings and pounds; it's not in its right mind. Don't tie it down. Don't lock it up. It is still being born. The water crashes against the stone and its infinite eyes open for the first time. They close again, not to die, but to keep on being born.

Afterword

Pablo Neruda once declared that if he had not been a poet, he would have built houses. He might have added that he did build houses. Before he died on September 23, 1973, exactly twelve days after the death of the democratic Chile that he loved so dearly, he had managed to buy three houses in three different locations and had spent years enlarging them, appending spires and rooms, galleries and watchtowers, guesthouses and libraries.

The house in Valparaiso was ransacked after his death, and Matilde, his widow, has refused to fix it. It remains as it was the day the soldiers decided to call: the windows shattered, the doors broken, the furniture splintered, the paintings slashed. Matilde wanted that ravished home to be a symbol. If Pinochet's men treated Chile's Nobel Prize winner in that way, treated the greatest poet in the Spanish language that way, the world could imagine, Matilde said, the way in which they would be treating Neruda's readers: the poor, the unprotected, the unknown.

The second house is in Santiago. When Matilde returned to it from the hospital with Neruda's dead body, the house was flooded. Troops had broken in and left the water in the kitchen and bathrooms running. Neruda's coffin — not a black one, he hated that color — was placed on a table in the middle of the overflowing mud and rubble.

His third house is the most famous; his home in Isla Negra, a tiny coastal hamlet of rocks, surf and gulls sixty miles west of Santiago. It was also invaded by soldiers, but not ravaged. This may have been due to the fact that the poet was there, dying of cancer, when they came. They were looking for weapons, for guerrillas, for communists: they opened each

book, original editions of Whitman and Rimbaud; they clicked their flashlights into his collection of shells and of frigates in bottles; they looked behind his seventeenth-century maps of America and behind the figureheads of schooners that he had carried back with him from all the corners of the earth; they even searched a small-sized, many-colored locomotive that he had in his front yard, one of the delights for the children who came to visit.

When he finally confronted the poet in bed, the major in charge of the operation was flustered and excused himself: "I'm sorry, sir, but we have been informed that there is something dangerous here."

Legend has it that Neruda answered: "Very dangerous indeed. It's called poetry."

The major coughed and then withdrew his men from the search.

It was after this military operation, that Neruda's illness worsened. The physician who had been taking care of him was arrested. Neruda left for Santiago, never to return to Isla Negra. On the way back, his ambulance was searched and then delayed for three hours. Matilde says it was the only time in her life that she saw Neruda cry.

During all my years of enforced exile, I have not been able to visit any of Neruda's houses. So one of my first acts, upon arriving in Chile was to visit Isla Negra. If Chile were democratic, it would have been natural not only that I should have gone, but that I should have slept and worked there: Neruda had left his house to Chile's poets, young and old, so we could live and write by the sea with all our expenses paid. He had made the Chilean Communist Party, of which he was a prominent member, the executor of that clause in his will. When the Junta confiscated all the possessions of left-wing parties, Neruda's magical house also fell into their hands. Just as the major had been disconcerted by the sight of Neruda, so the government had not known what to do with his house. Even

the absurd General Pinochet found it unreasonable that he should open this house to the very writers he had spent the last ten years persecuting and beating up, censoring, kicking out of jobs and sending into exile. So the government did the only thing it could do: shut the house up and let it deteriorate. After all, the police must have thought, how much harm can an abandoned house do?

At first glance, this surmise seems correct. The room is boarded up where Neruda used to munch cheese and write verse, watching the waves burst on the shore. The round-eyed fish he painted along the outside walls—along with many other symbols—are peeling. Inside, one can imagine the books growing moldy.

It is, nevertheless, a heartening sight. A fence surrounds the house, and on each of its slats, messages have been scribbled—hundreds, thousands of messages. People have come from all over Chile, and from all over the world, to write something on that fence. They speak to Neruda directly, calling him Pablo, and using the familiar "tu" instead of the more distant "usted." Some are political slogans, but most are declarations of love, short poems, random thoughts. Sometimes it is a couple of lovers who sign, lovers who have used Neruda's verses as a bridge between them; very often it is groups of teenagers; and also whole families. I stopped and was particularly moved by one list of ten people, all with the same surname. At the bottom someone had scratched: "And also Pablito (2 years old)."

Scores of ordinary people had felt that they could not be silent, that their words had enough significance to be left as a gift for others. By pledging their troth, by scrawling their names, by thanking a dead man for interceding in heaven, they were telling Neruda how much they missed him, how far away he was. Some of the messages were carved in the wood, but most had been written with chalk or coal. When the rains came,

they washed the phrases away and then other visitors came, to inscribe new vows.

This is how Chile has survived ten years of dictatorship. Thousands have journeyed to Neruda's house; but many millions more have inscribed on other fences other kinds of words. They have somehow kept a part of themselves intact, and have been able to find minimal, marginal, anonymous ways of expressing that part to their fellow countryfolk.

— Ariel Dorfman

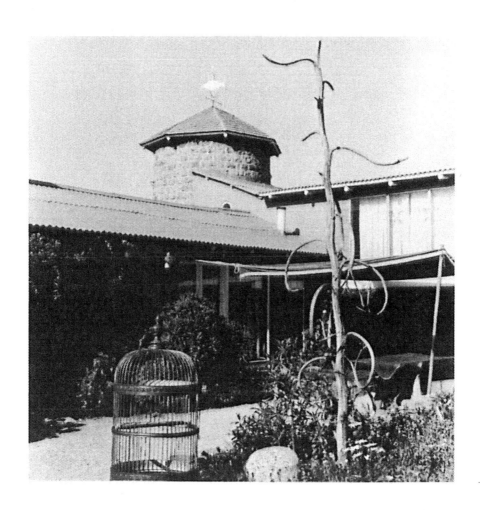

Dennis Maloney is a poet, translator, and landscape architect. His books of translations from Spanish include *There Is No Road: Proverbs by Antonio Machado* (with Mary G. Berg), *The Stones of Chile* and *Isla Negra* (with Maria Jacketti and Clark M. Zlotchew), both by Pablo Neruda, and *The Landscape of Soria* by Antonio Machado. His translations from Japanese include *Dusk Lingers: Haiku of Issa* and *Tangled Hair: Love Poems of Yosano Akiko*, both with Hide Oshiro. Several volumes of his own poems have also been published.

Clark M. Zlotchew, professor of Spanish at the SUNY College at Fredonia, is a literary critic, writer of fiction, and translator. He is the author of the military action novel, *TALON Force: Dire Straits* (under the pen name Cliff Garnett). His *Macmillan Teach Yourself Spanish in 24 Hours* will be published in a new edition as *Alpha Teach Yourself...* in 2004. He is the author of *Voices of the River Plate: Interviews with Writers of Argentina and Uruguay* and of *Libido into Literature: the "Primera Época" of Benito Pérez Galdós.* Dr. Zlotchew is the translator of *Seven Conversations with Jorge Luis Borges* by F. Sorrentino and of *Falling Through the Cracks: Stories of Julio Ricci.* He is the translator of the Honduran section of *Recent Central American Short Story Writers (1968–1988).* He is also the author of numerous articles on Spanish and Latin-American literature. His short stories have appeared in English and in Spanish literary magazines.